TO LUCA, FRANCESCA, IAN AND RACHAEL

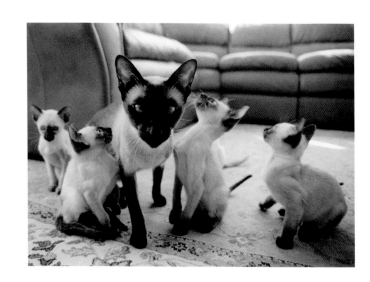

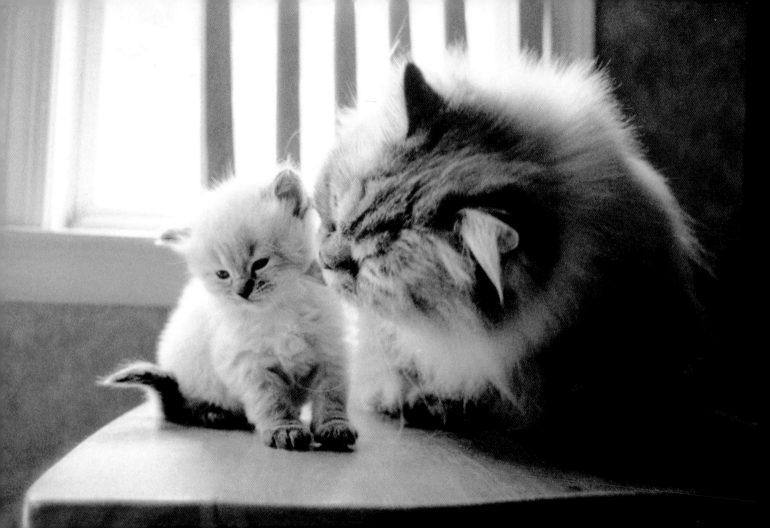

caternal INSTINCTS

THE FELINE GUIDE TO MASTERING MOTHERHOOD

Photographs by KIM LEVIN

Written by CHRISTINE MONTAQUILA

STEWART, TABORI & CHANG • NEW YORK

Published in 2007 by Stewart, Tabori & Chang
An imprint of Harry N. Abrams, Inc.

Text copyright © 2007 Christine Montaquila
Illustrations/photographs copyright © 2007 Kim Levin

Project Manager: Marisa Bulzone
Editor: Dervla Kelly
Designer: Susi Oberhelman
Production Managers: Devon Zahn and Jacquie Poirier

ISBN 10: 1-58479-570-0
ISBN 13: 978-1-58479-570-4

The text of this book was composed in Futura and Berthold Bodoni.

Printed and bound in China by Midas Printing Ltd.

10 9 8 7 6 5 4 3 2 1

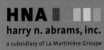

HNA
harry n. abrams, inc.
a subsidiary of La Martinière Groupe

115 West 18th Street
New York, NY 10011
www.hnabooks.com

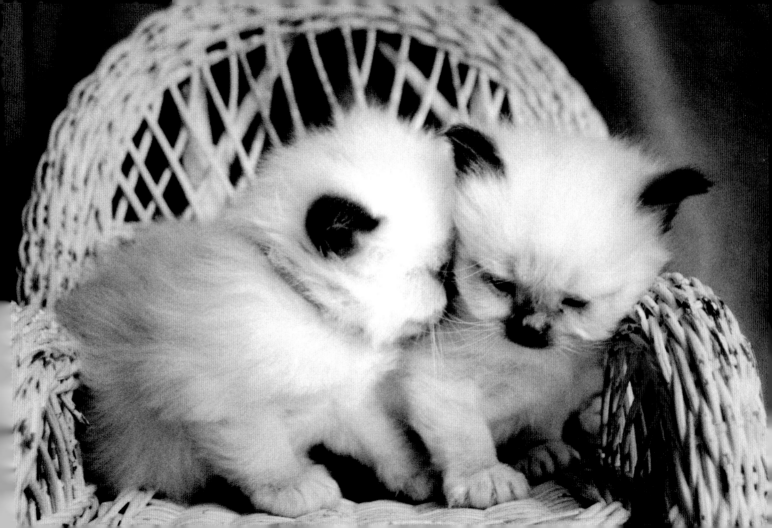

Consider all moments of silence suspicious.

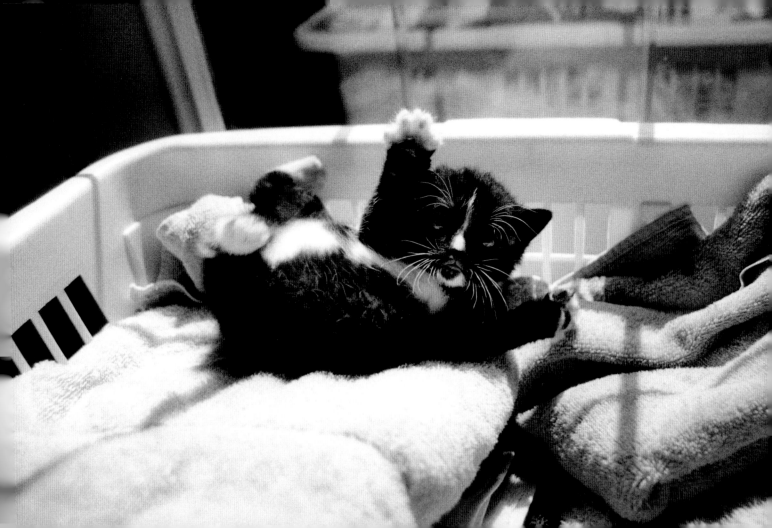

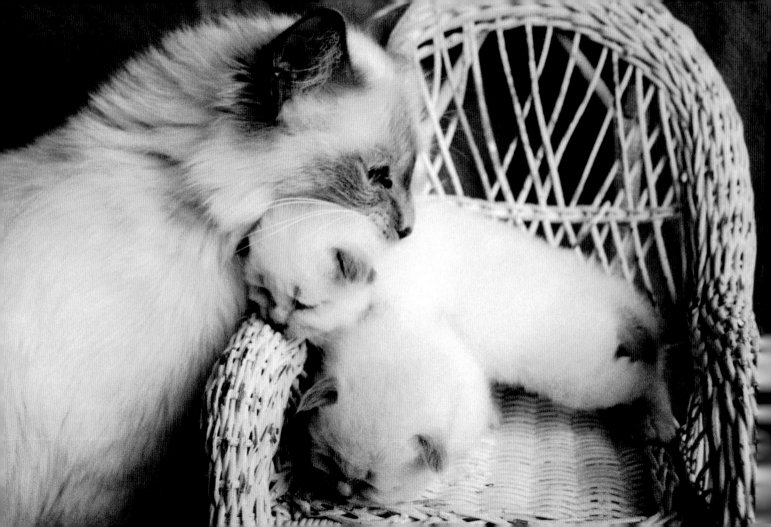

Make sure your **back** is as **strong** as your coffee.

ALOUETTE – MOMCAT; KITTENS – TWO WEEKS OLD

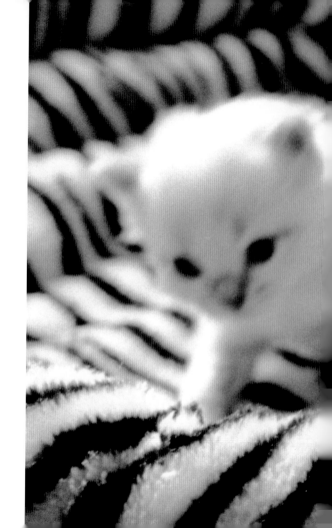

Think in bulk.

THREE WEEKS OLD

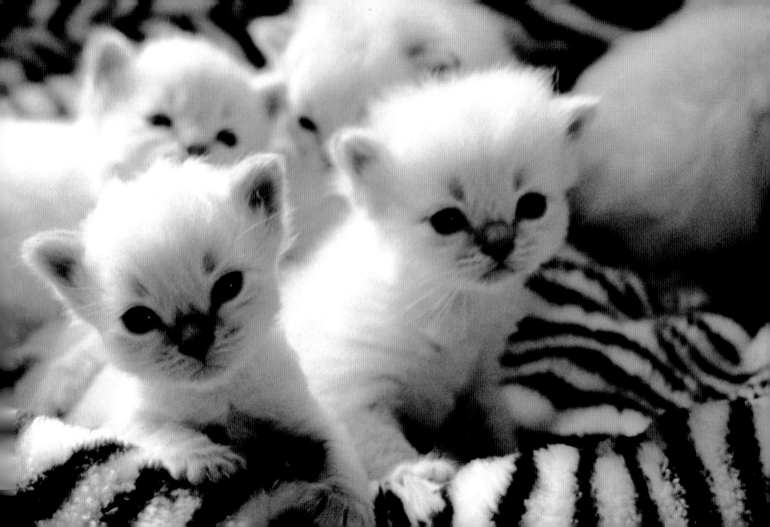

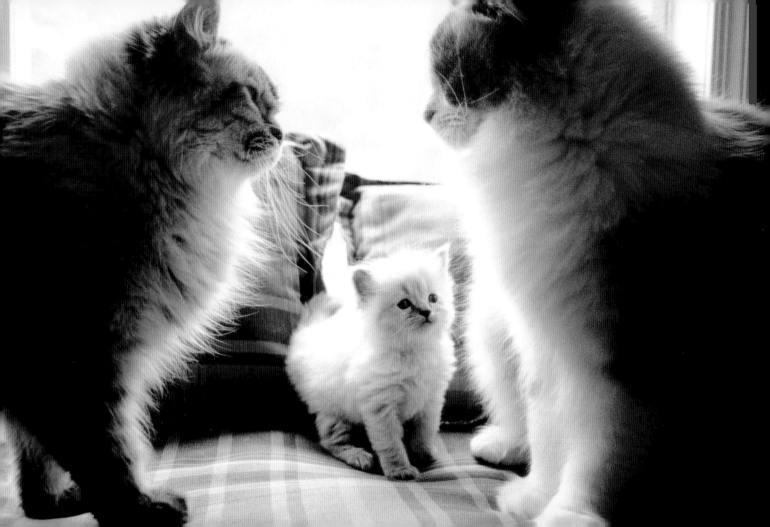

Pretend to agree until you're in private.

BEE – MOMCAT; KITTEN – FOUR WEEKS OLD; LARDIE – DADCAT

Buy stain resistant everything.

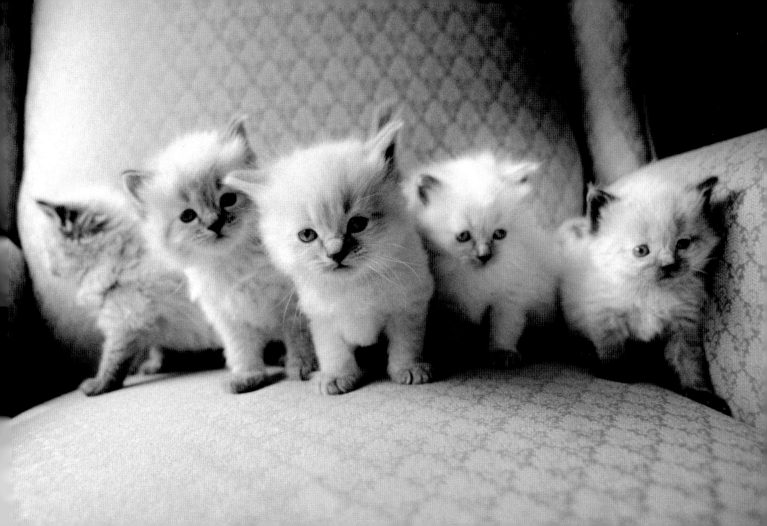

Enjoy your temporary status as a superhero.

NINA – MOMCAT; KITTEN – THREE WEEKS OLD

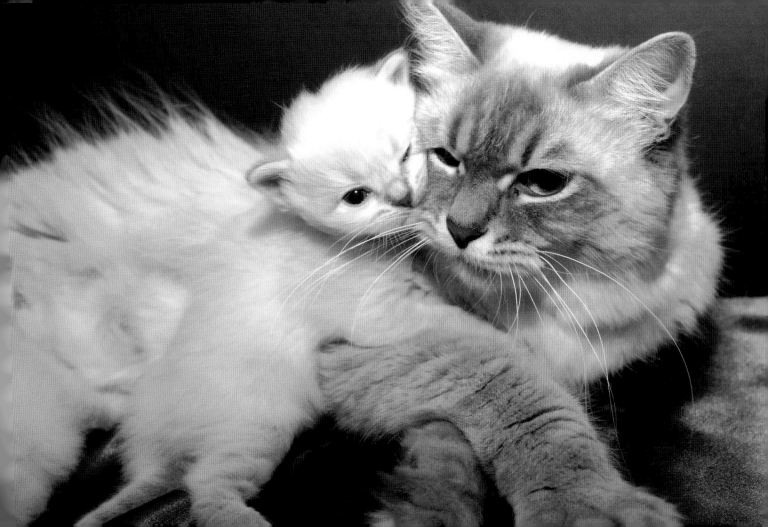

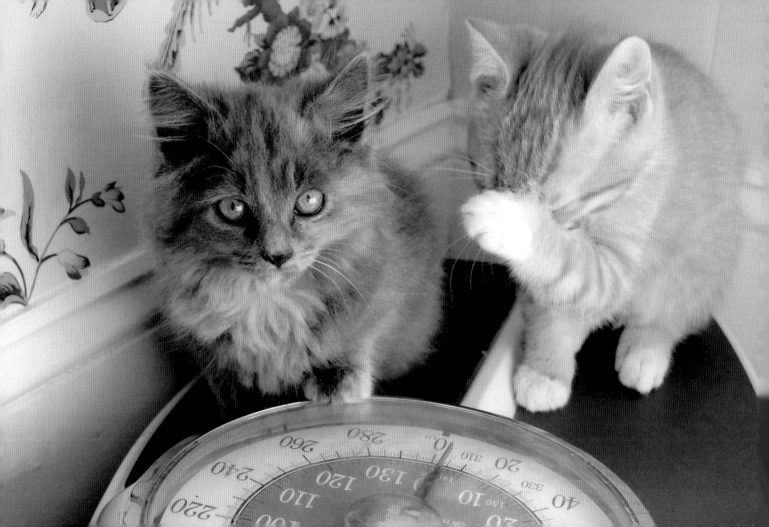

Teach your girls to love their curves.

NINE WEEKS OLD

Teach moderation in everything but affection.

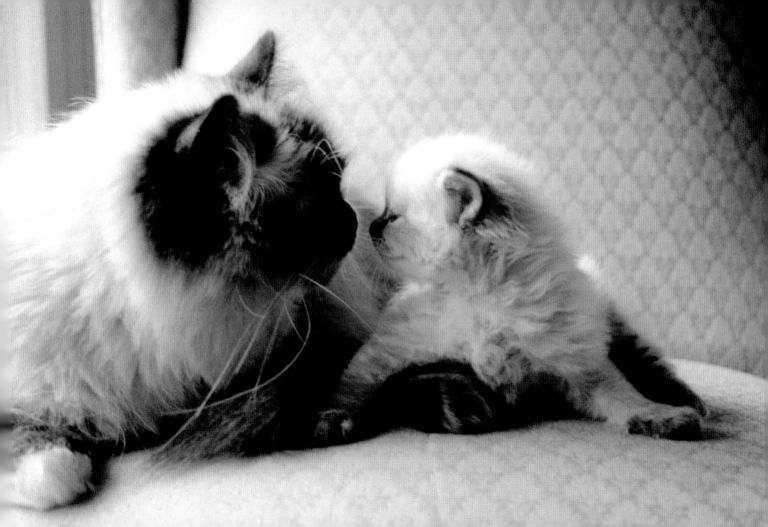

Make sure they know a good comeback.

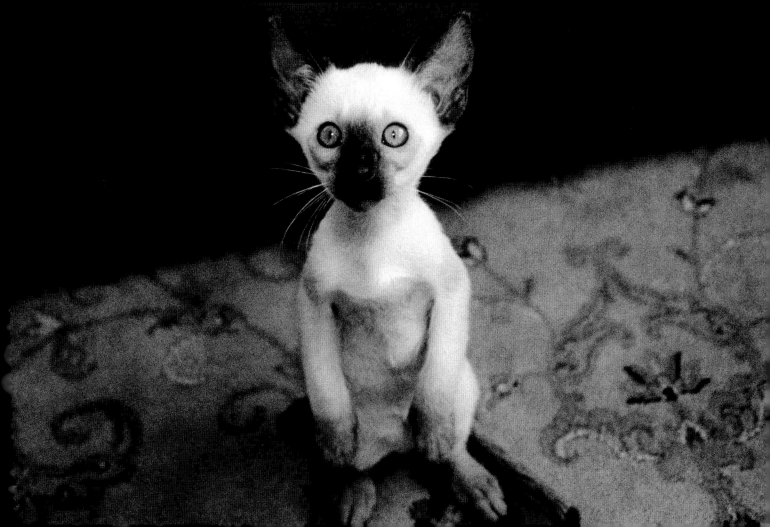

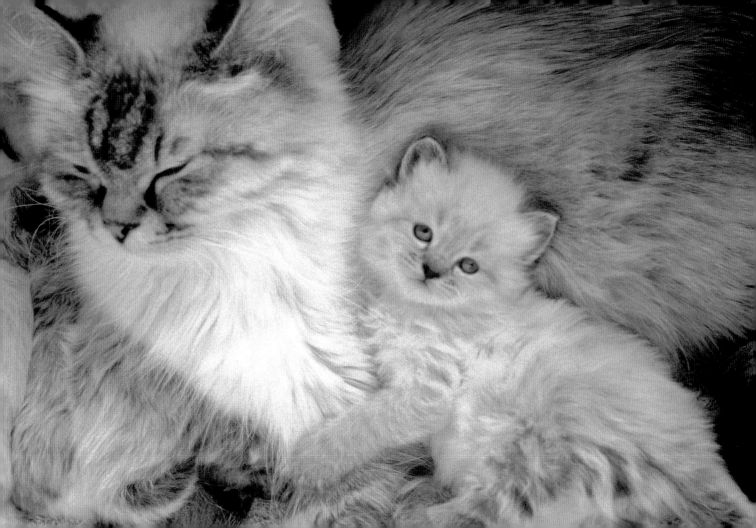

Take your job as a monster-repellent seriously.

Resist the urge
to buy every
gigantic plastic
toy you see.

TEN WEEKS OLD

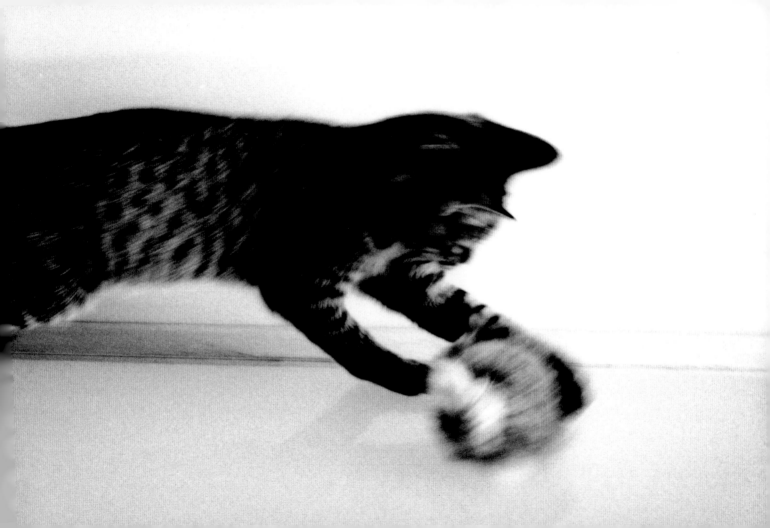

Get way more strict during the dating years.

NINA – GERMAN SHEPHERD; KITTEN – SEVEN WEEKS OLD

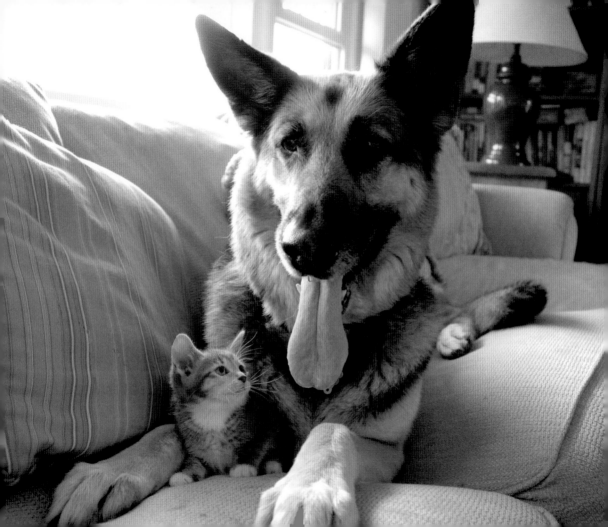

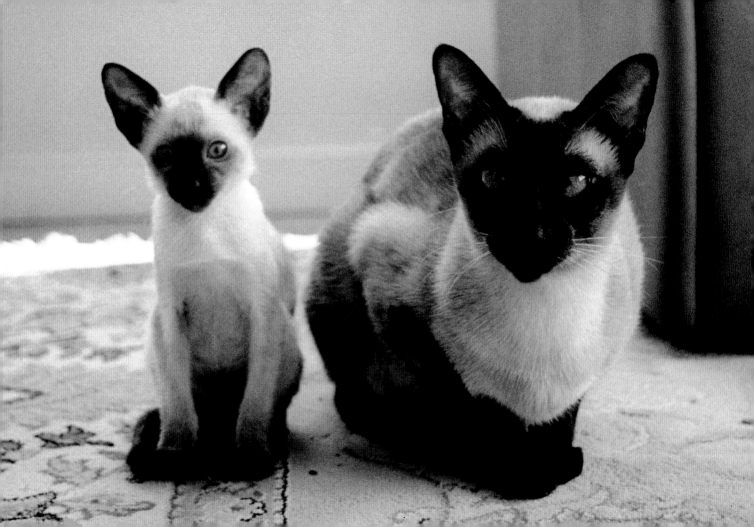

Tell them their good looks are their inheritance.

NEO – MOMCAT; KITTEN – NINE WEEKS OLD

Don't put them in outfits you'll regret later.

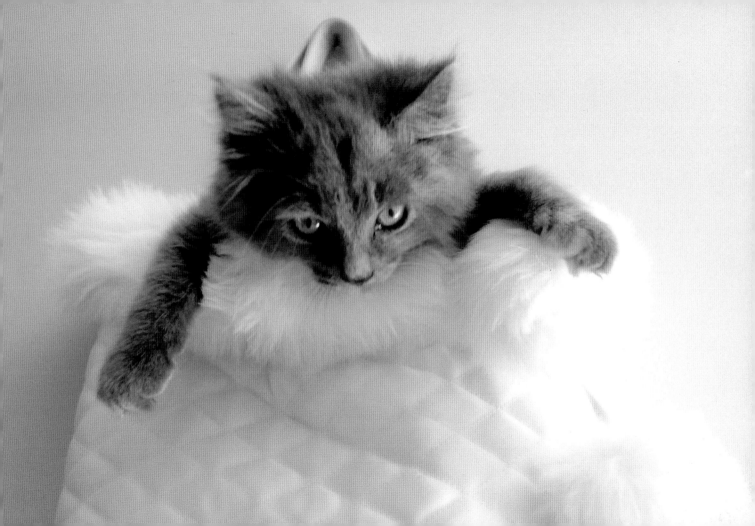

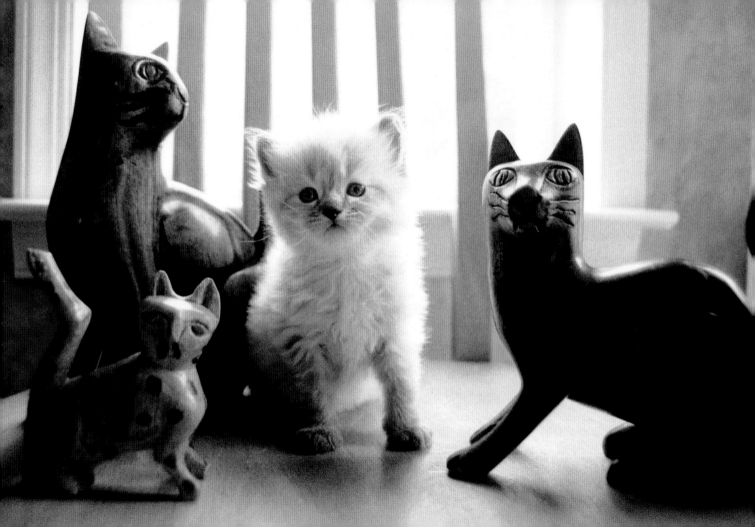

Roll with the **imaginary friends.**

FOUR WEEKS OLD

Help them answer life's big question,
"Who am I?"

NINE WEEKS OLD

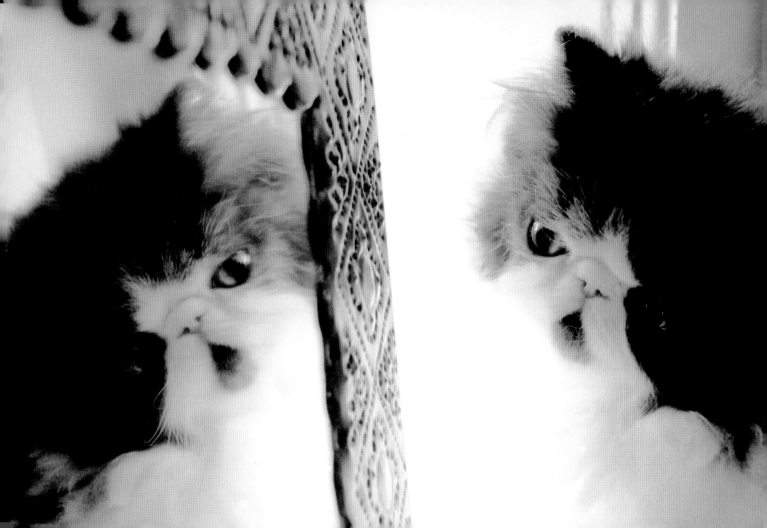

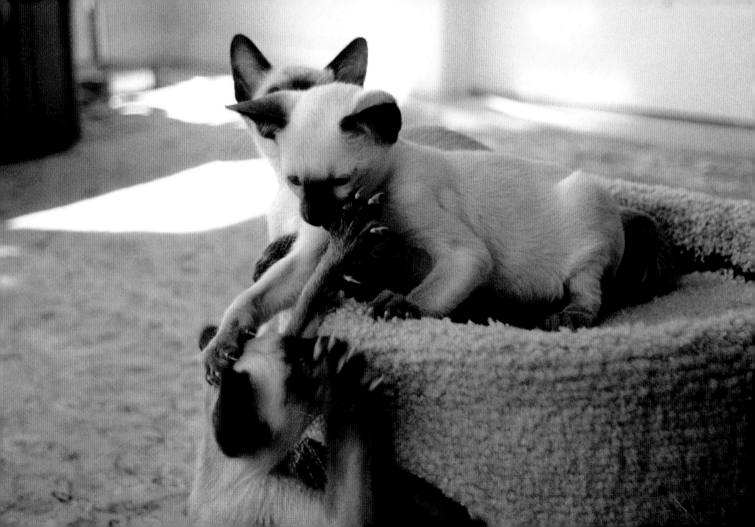

Know the way to the nearest emergency room.

NINE WEEKS OLD

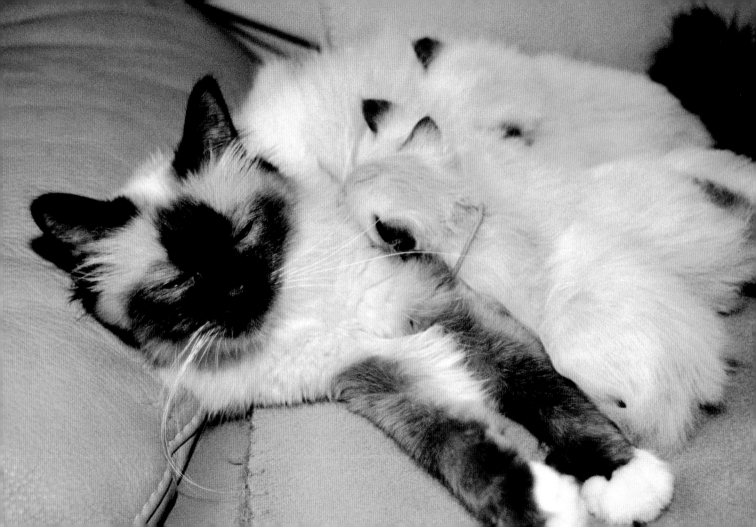

Realize snacks can work like sedatives.

Accept that you'll never complete
a thought or conversation again.

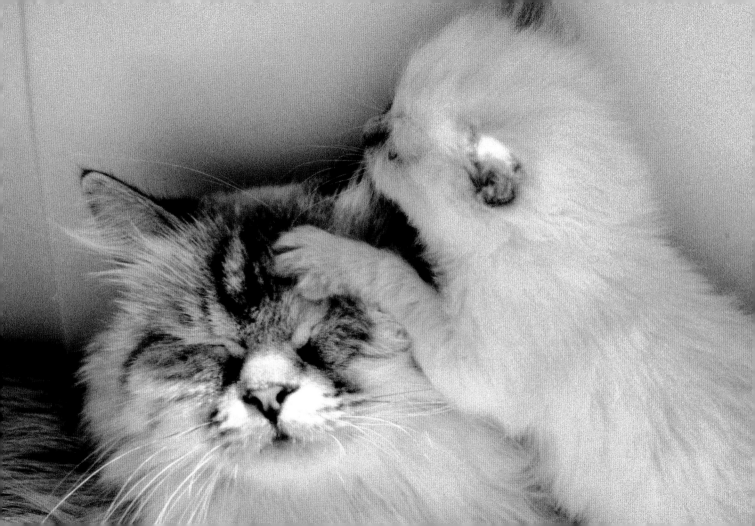

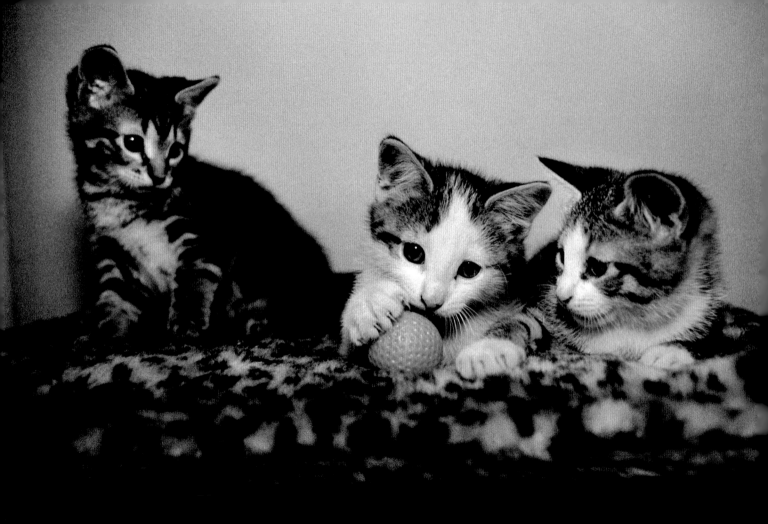

Teach them to share.
Don't expect them to actually do it.

Explain to friends
 that you are now
 a package deal.

CHAY – MOMCAT; KITTEN – TWO WEEKS OLD

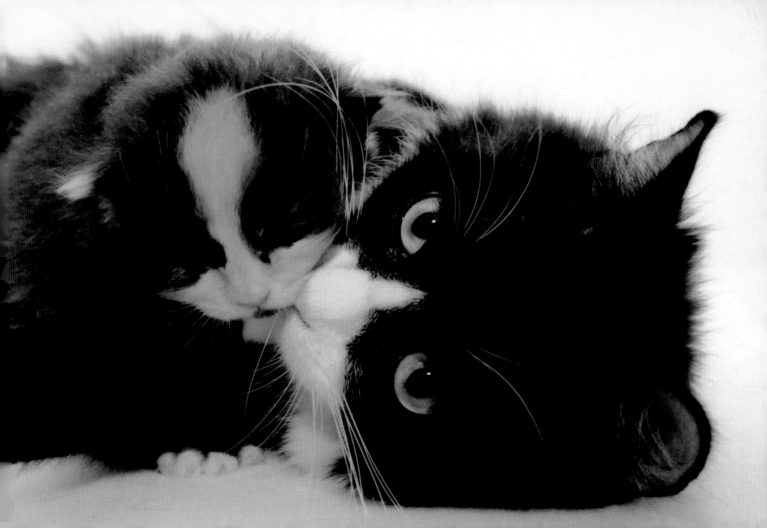

Declare babysitting an official form of exercise.

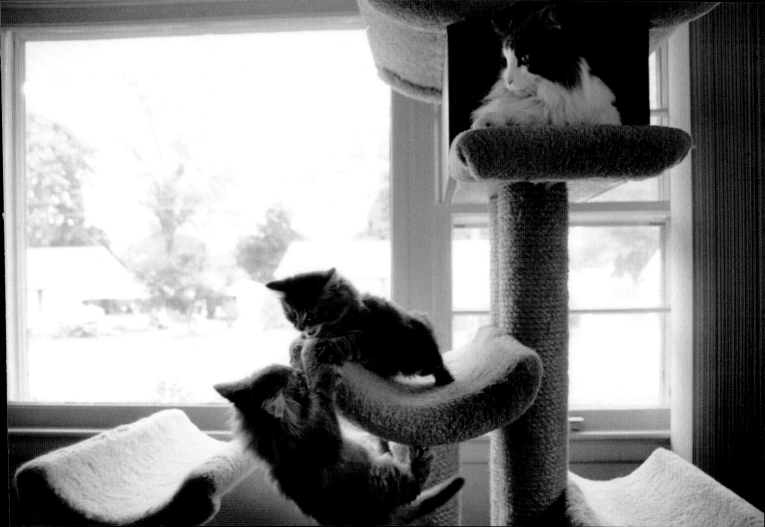

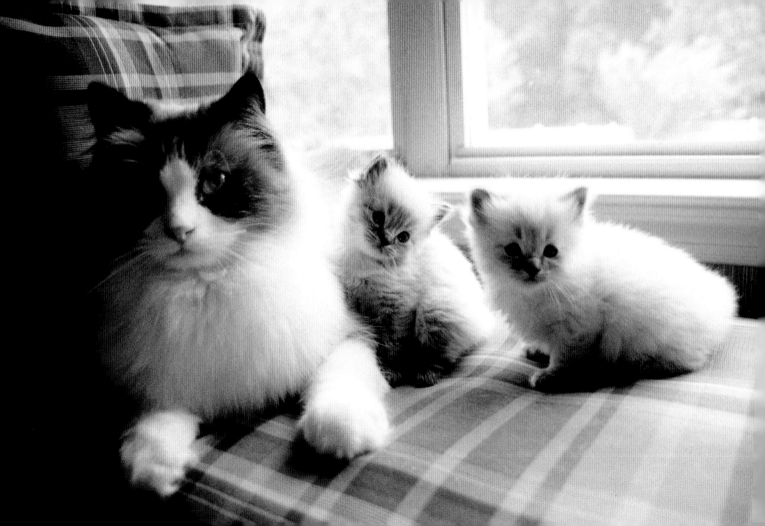

Give them the **gift** of **boredom**.

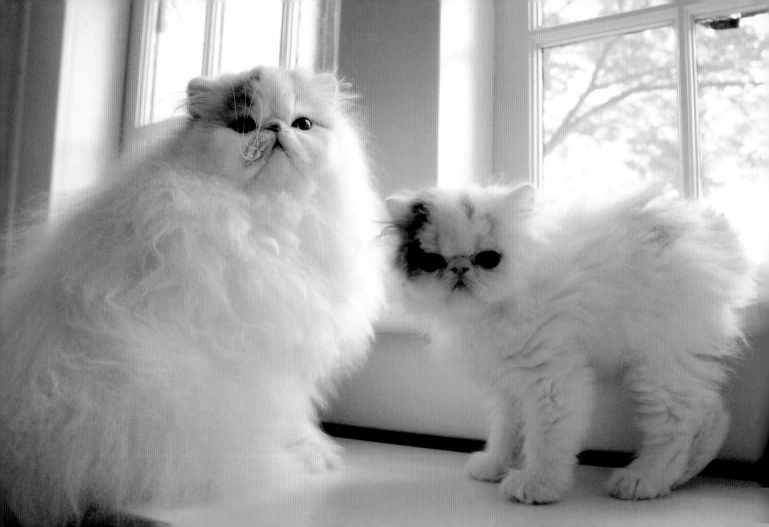

Be a role model for good manners and good hair.

Savor those nanoseconds of serenity.

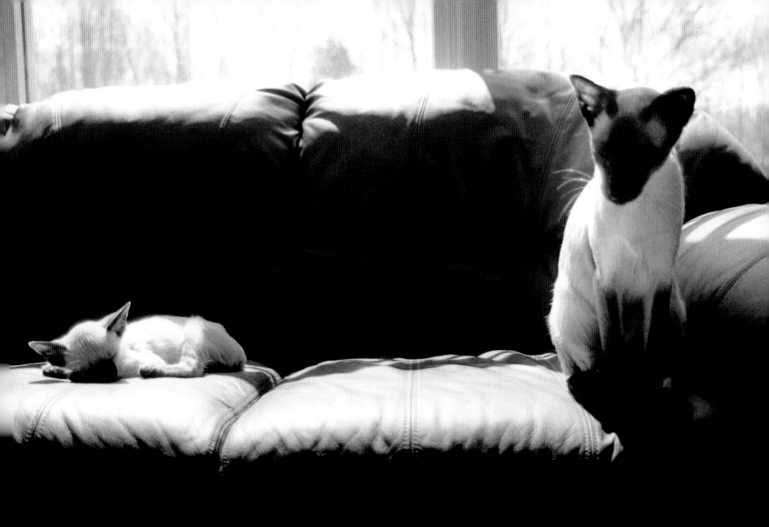

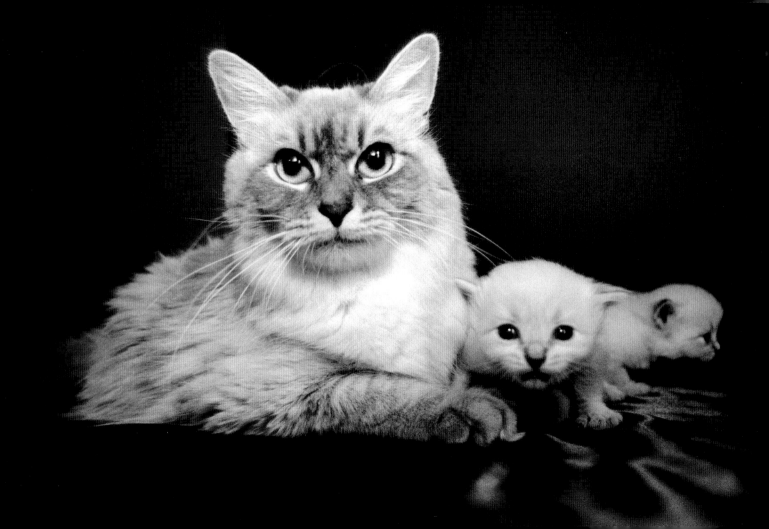

Give up the notion of **on-time arrivals.**

NINA – MOMCAT; KITTENS – THREE WEEKS OLD

Learn the art of speed primping.

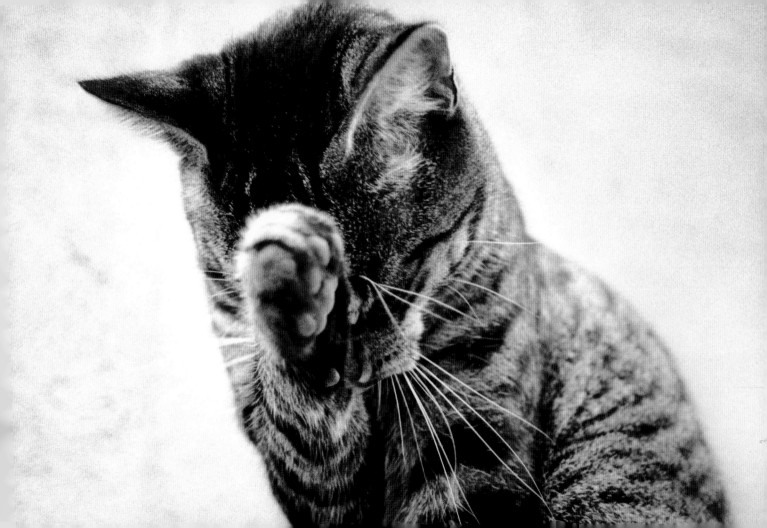

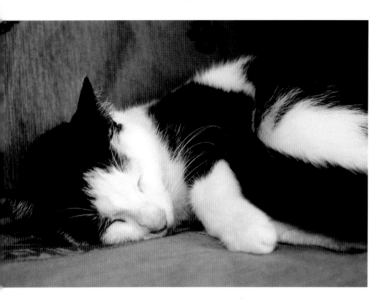
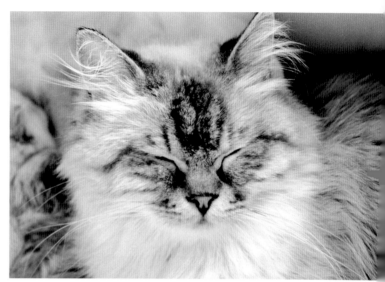

Make naptime non-negotiable.

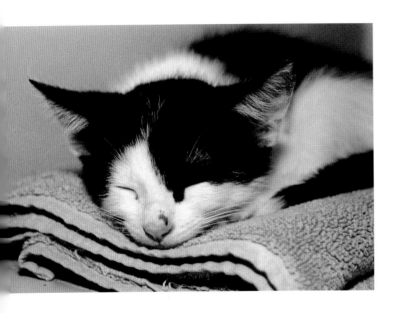 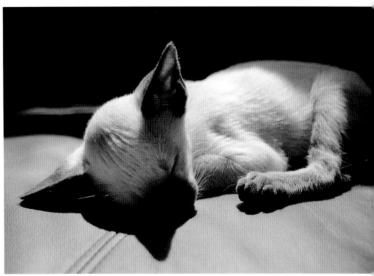

MOMCATS - ISABELLE, BEE; KITTENS - NINE WEEKS OLD

ACKNOWLEDGMENTS

Big wet kisses to Marisa, Dervla, and STC for their continued support of our vision. To the breeders, foster parents, and shelters in New York and New Jersey who opened their doors and homes for this project. To Jim Hutchison for turning our contact sheets into pretty pictures. To our fabulous families for their shameless promotion. And to those magnificent, always composed momcats, who make raising eight at once look easy.

FOUR WEEKS OLD

ABOUT THE AUTHORS

By day, CHRISTINE MONTAQUILA works in advertising as a creative director. She lives in Chicago with her husband Brad, son Luca, daughter Francesca, and gray tiger cat Maddie.

KIM LEVIN is a photographer who specializes in pet portraiture. Her company, Bark & Smile® Pet Portraits, combines her passion for photography and her love of animals. Kim has published fourteen books including *Cattitude*, *Why We Love Dogs*, *Why We Love Cats*, *Growing Up*, *Dogma*, and *Hound for the Holidays*.

A passionate advocate of animal adoption, Kim has been donating her photography services for many years. Kim lives in Little Silver, New Jersey, with her husband John, her son Ian, daughter Rachael, and Charlie, their adopted border collie/greyhound mix. Visit Kim's photography at www.barkandsmile.com.

Kim and Christine have been best friends since the 7th grade.